Jumping Cholla

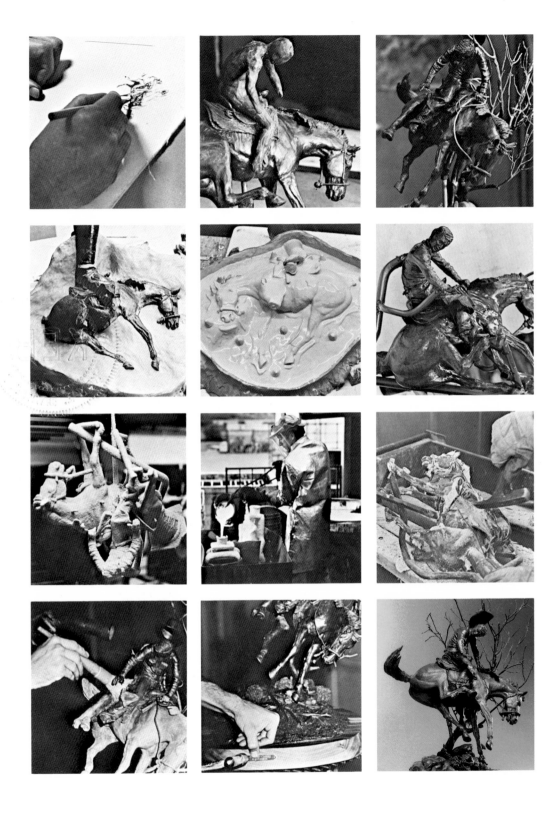

Jumping Cholla

Genesis of a Bronze Sculpture

by Keith Christie

NORTHLAND PRESS / FLAGSTAFF

To my wife Vaughn
and my children Jackie,
Ken, and Jenny

FIRST EDITION
ISBN 0-87358-291-8 hardcover
ISBN 0-87358-292-6 softcover
ISBN 0-87358-290-x limited edition
Library of Congress Catalog Card Number 81-66720
Composed and Printed in the United States of America

Contents

Acknowledgment

It is with deep appreciation that I acknowledge the help and encouragement given me in the writing of this book. I would like to thank Jerry Eaton of Sculptor Service for allowing me to photograph the process of mold making, preparing a wax for casting, chasing a bronze, and the application of the patina. Thanks also to Chuck Lund of Lund Casting for allowing me to photograph the investment, burnout, and casting of a bronze sculpture and to Harold G. Davidson and Jim Clark for their helpful suggestions to collectors. To my wife Vaughn, a special thanks for her help with the photography, her criticism, and her encouragement, but most of all, for her faith.

Preface

I believe the question I hear most frequently when someone is looking at one of my bronze sculptures is: "How long does it take to make it?" The second most-asked question is, "How do you make it," and third, "Why does it cost so much?"

These are all very legitimate questions. However, in attempting to answer them, I invariably lose the listener with the complex problem of describing a process that really has to be seen. Therefore, I will be using photographs to illustrate this process as much as possible. It is my hope that this book will answer these questions and many more.

Jumping Cholla is an attempt to help the collector, or those who just admire bronze sculpture, understand the process of manufacturing a bronze. I am not trying to write a "How To" book for aspiring artists, for such a book would require a great deal of technical information not needed by the collector; nor do I set myself up as an expert in either sculpture or bronze casting. Rather, I have attempted to explain my approach to sculpture and how that sculpture is transformed into a bronze. Also, it should be noted that the processes shown in this book are not the only processes or procedures used to sculpt or cast a bronze sculpture. They are, however, the ones that I use most frequently.

In Part Two of this book, I have presented the opinions of some experts in the field of art. They have some very interesting advice for anyone who is either an admirer or collector of bronze sculpture.

The Sculpture and Casting Process

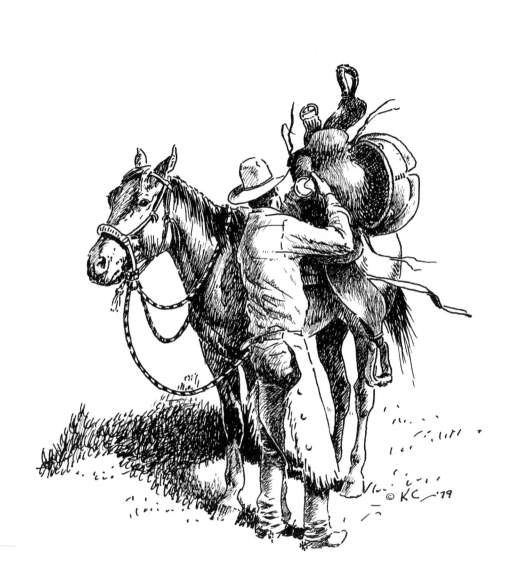

The Idea

Before any art form can exist as a completed project, it must first exist as an idea in someone's mind. For the artist, ideas or inspiration can come from many sources. It has been my experience that most artists really do not have too much trouble coming up with ideas for their work. The biggest problem seems to be having enough time to complete just some of the ideas that they do come up with.

Whenever I think of an idea for a bronze, I run the idea through my mind, pretty much the same way a football coach must run a new play through his mind. My ideas, therefore, have action. Something is happening before and after the pose that is sticking in my head. Once I have stopped the action, I turn the piece around in my mind to look at it from all sides. This is an important step because a bronze will be viewed from several sides or angles, unlike a painting or drawing that will be viewed from only one side.

The idea for the sculpture covered in this book started to germinate as I was driving from Scottsdale to Prescott, Arizona. As I drove past some signs identifying desert plants, I noticed the sign marked "Jumping Cholla."

I have ridden horses who came in contact with this plant and witnessed their reaction. It is always unpleasant—and sometimes violent. The picture of a green-broke horse busting in half with a piece of cholla stuck to his leg came into my mind. I also started to think about the problems encountered in the sculpting of a bucking horse. I am, like most sculptors, in a constant battle with Mr. Newton's law of gravity.

I wanted to do a bucking horse with all four feet off the ground. This presents some artistic and engineering problems. In the first place, I wanted to avoid the appearance of impaling the horse. Therefore, I needed to strike a balance between the artistic illusion of a horse in mid-air and the engineering constraints for holding it there. I needed something that looked natural so I thought

The sign identifying jumping cholla seen along Scottsdale Road near Carefree, Arizona

Jumping cholla is a wicked little plant.

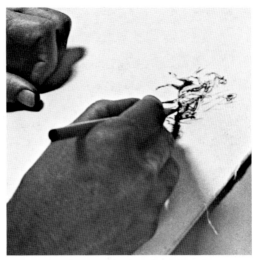

I made a quick sketch of the idea.

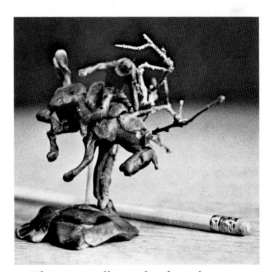

The giant saguaro, which is seen in
and identified with the Southwest

This is a small wax sketch used to get a
three-dimensional feel for the sculpture.

about having the horse buck into a giant saguaro. The more I thought about that idea, however, the less I liked it. Saguaro looks so heavy and stable that it would probably stop any action in the piece. I put the idea away in a corner of my mind; it was several days before I brought it out and looked it over again.

This time I ran the horse into a small dead tree. This idea had some possibilities. Here again, I turned the piece around several times in my mind. I also made a quick sketch to see if it would work on paper. The idea still appealed to me, so I made a small wax sketch and went to work on the wax sculpture.

The Sculpture

The wax used in the sculpture is actually a synthetic wax called microcrystalline. It is manufactured by a variety of oil companies and can usually be purchased from a foundry in slab form.

 To start the sculpture, I cut a small supply of wax strips from the slab. These wax strips can easily be warmed in my hand or, as seen later, in a double boiler.

 I always start my sculpture with the horse's head. I have several reasons for doing this, but the most important reason is that I use the size of the horse's head to determine all other proportions in the piece.

 As the drawing shows, a horse's conformation can be broken down into

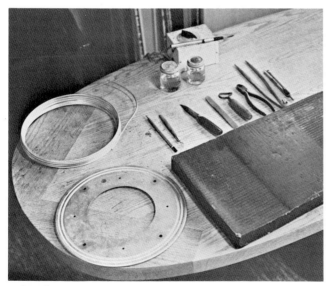

Left: This picture shows the tools and materials used for the sculpture (a slab of wax, a lazy susan, a coil of aluminum wire, a wax welder, and various other tools). Right: Strips (like jerky) are cut off the slab of wax.

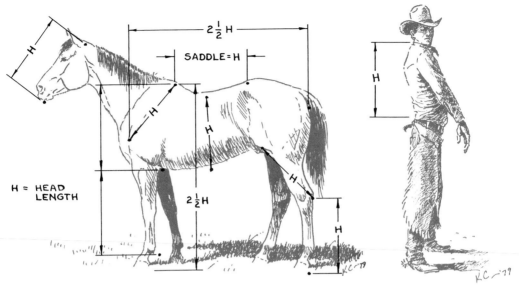

Left: The horse's proportions are based on its head size. Right: The man's proportions are based on the head size of the horse.

Starting the horse's head

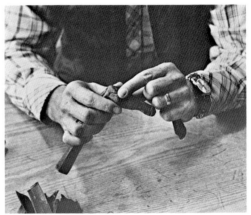

Getting the basic skull shape

various parts related to the length of its head (life size approximately twenty-two to twenty-four inches).

I also use the head length to determine the size of the rider and the saddle. For example, the distance from the man's waist to his neck is equal to the length of the horse's head. A saddle, which is usually twenty-four to twenty-eight inches, can easily be proportioned to the horse's head length.

The Horse and Saddle When sculpting a horse's head, I first try to get a basic skull shape, and then I position two round balls of wax to represent the eyes. I

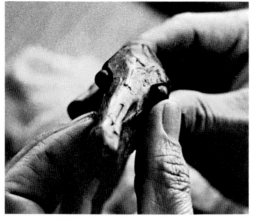

Putting the eyeballs into position

Rolling out a coil of wax

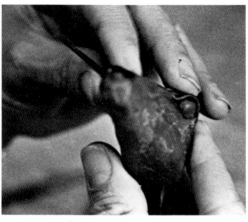

Using the wax coil to shape the eye

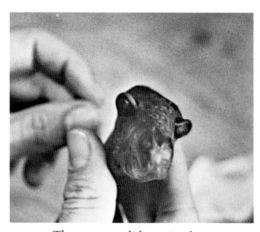

The upper eyelids are in place.

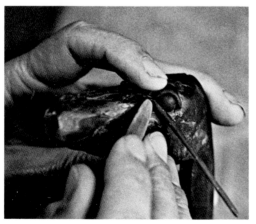

Starting the lower eyelids

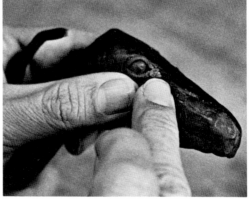

Eyelids are in place and work is started on the
bone structure around the eye.

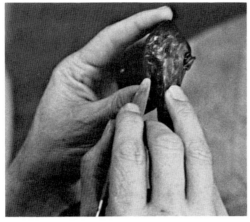

One side of the head is almost complete.

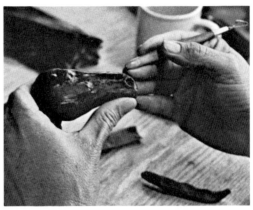

The eyes are now complete, and the rest of the head is starting to take shape.

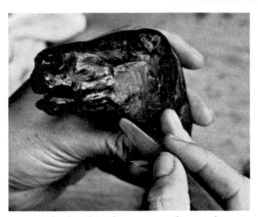

The head is almost complete and ready for the live model.

A live model happily doing her duty

like to finish the eyes and work out from them. Here again, I use certain proportions. The distance from the poll to the eye is approximately one-third the length of the head.

Once I have the head nearly completed, I like to take it out and refine it with the use of a live model. Now I am ready to build the body.

By warming a large quantity of wax in a double boiler, I can pick up the soft wax and press it into the desired shape in a short length of time. As I work, I am constantly using my calipers to check the body for size and proportion.

I try to complete the horse's body down to the point of the elbow and to the second thigh. At this point, the wax is getting too heavy to continue holding in my hands, so I build a temporary stand to hold the piece in position while I work on finishing the horse's body.

Strips of wax are placed in double boiler
and warmed to about ninety degrees.

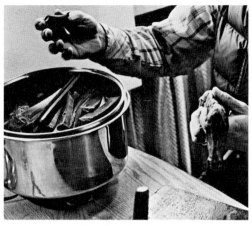

Starting the body

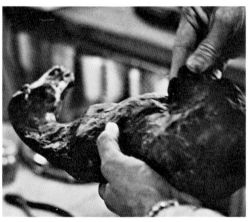

A rough body shape is almost complete.

Checking the proportions of the body using
the length of the head as a guide

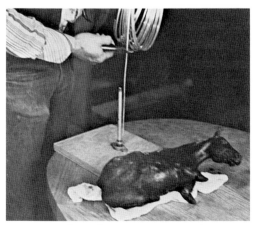

Making the temporary stand

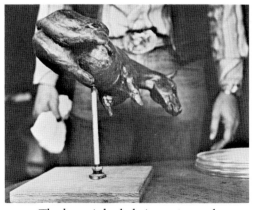

The horse's body being supported
by a temporary stand

9

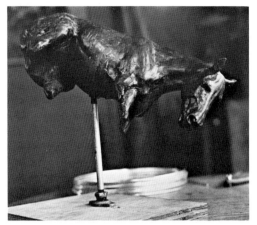

The body of the horse is almost complete.

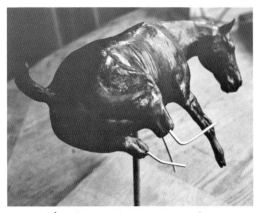

Aluminum wires are inserted to support the tail and legs.

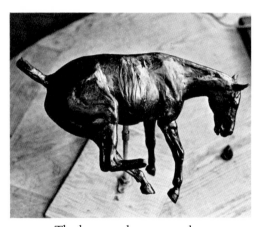

The legs are almost complete.

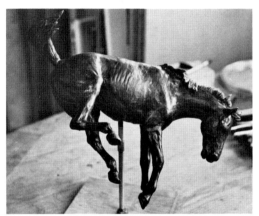

The horse is complete.

When the body is complete, I insert aluminum wires to reinforce the tail and legs. To make sure that proportion and anatomy are correct, I constantly check measurements while the work is going on. I prefer to complete the horse in great detail before proceeding to the saddle.

To make the saddle, I first put the saddle blanket on the horse and then proceed to make the saddle from the inside out. I also sculpt the stirrups at this time, but they are set aside to be added later with the man. Once satisfied with the saddle, I am ready to secure the horse to a larger base and to start on the man.

To place the horse on a larger base, I embed a pipe in the horse's belly. This pipe is secured to a union so that the horse can be removed from the base when it is time to make the mold.

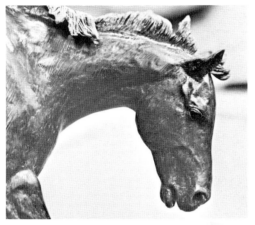

Detail of the finished head

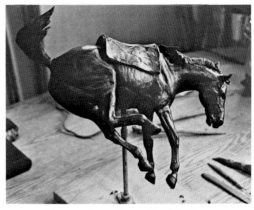

I now place the saddle blanket
on the horse's back.

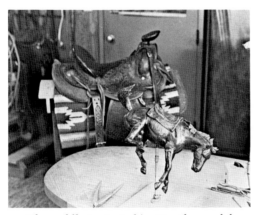

The saddle is started (notice the model
in the background).

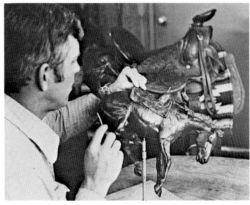

Here I have added the seat, fork,
and part of the rigging.

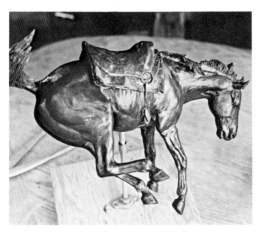

Cinch strap is added.

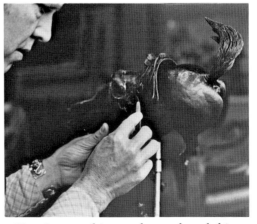

Here I am working on the cantle and skirt.

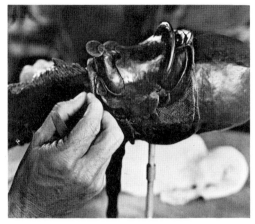

Adding some final details

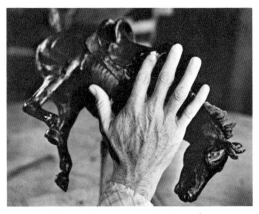

The saddle is smoothed out by rubbing it with kerosene.

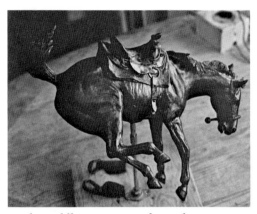

The saddle is now complete. The stirrups will be added later with the man.

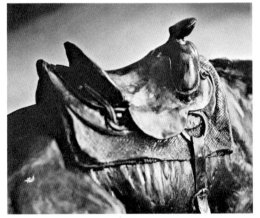

Detail of the saddle

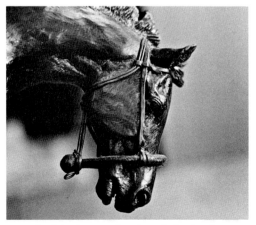

Detail of the horse's head with the hackamore

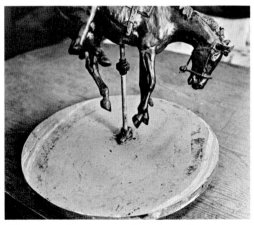

The horse is now transferred to a larger base.

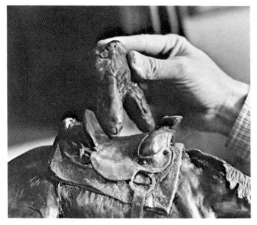

I first form the hips and thighs of the man.

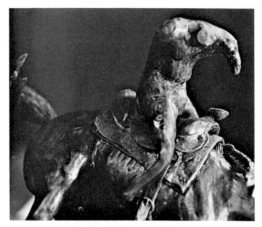

Rough shape of the upper torso

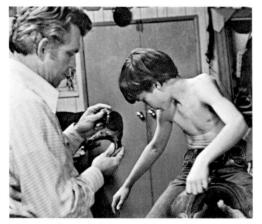

Using a live model to refine the man's shape

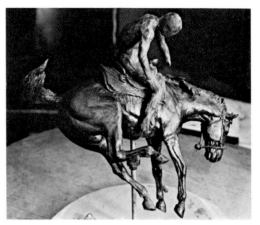

Side view of the nude figure

The Man I usually start the figure with the hips and thighs, which are made to fit the saddle. I then begin sculpting the upper torso—keeping it in proportion to the horse.

Once I have the rough shape of the man, I use a live model to refine the shape. I will use this model to complete the nude form—except for the head and hands. I sculpt the head and hands separately and add them to the body to complete the nude form. I am now ready to begin the clothes.

To dress the man, I use live models, photographs, and mirror images of myself. It is important to note that there are many places where the nude body shape and the clothes are almost one. For example, a great deal of the original nude form is left intact where a shirt lays on the man's back.

My usual procedure is to start sculpting the clothes from the feet up. This

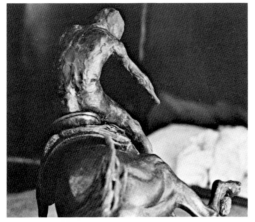
Back view of the nude figure

Sculpting the hands

Sculpting the head

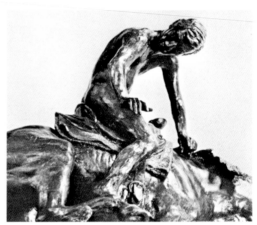
The nude figure is complete.

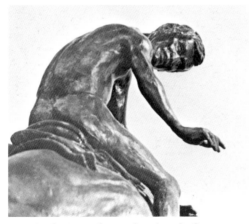
Back view of completed nude figure

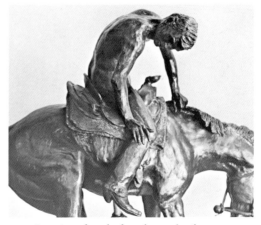
Starting the clothes from the feet up

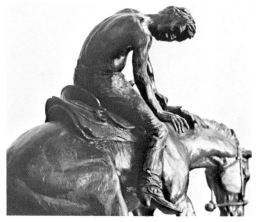

Pants completed

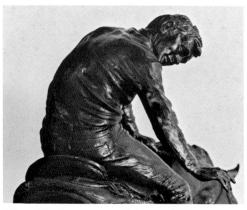

The shirt is now complete (note how a great deal of the nude form is still visible).

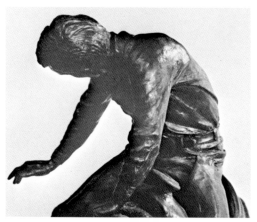

The chaps are started around the hips.

The chaps are almost complete.

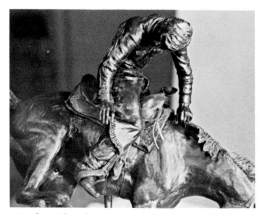

Right side of completed man (note stirrups are now added)

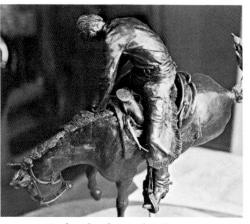

Left side of completed man

15

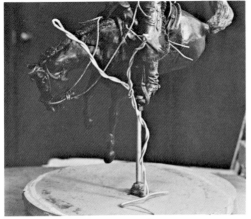

Wire armature for tree

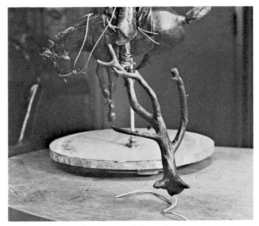

The tree taking shape

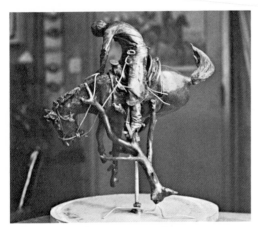

The tree set in place

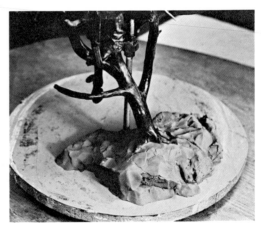

I now start the clay base.

is because most clothes are worn in layers with the items on top fitting over those worn below. For example, pants fit over boots, chaps fit over pants, etc.

Once I have completed the clothing, I add the stirrups to the man's legs and secure him to the horse and saddle. I am now ready to go to work on the base.

The Base The most important part of the base in this sculpture is the tree holding up the horse. Therefore, I start with an aluminum wire twisted to the approximate shape of the tree; I then add wax to this wire armature. Once I have the tree in its proper shape, I start adding plasticine (clay that is suspended in oil rather than water) to the base to form the ground and rocks. I use clay or plasticine for this step to save time, for I can form clay faster than wax. When I am satisfied with the shape of the rocks and ground, I can go to work on the textures.

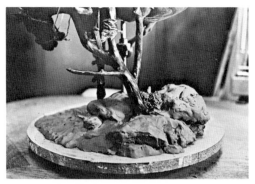
The base is almost finished.

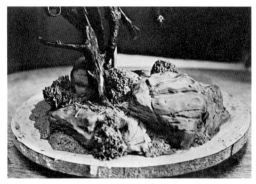
A back view of the finished base

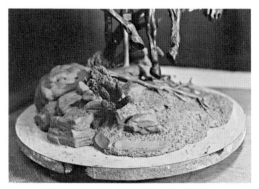
Front view of the finished base

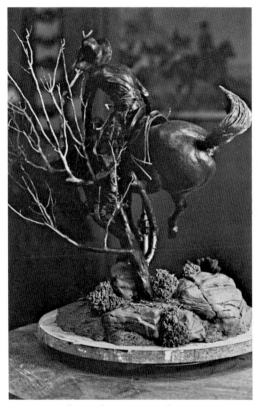
The sculpture is ready to go
to the foundry.

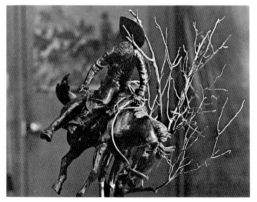
The branches are added to the tree.

As a final step, I add the broken manzanita branches to the base and the upper part of the tree. The jumping cholla in the foreground helps to identify and tie in the cholla on the horse's legs. The sculpture is now complete, and I am ready to transport it to the foundry.

The Rubber Mold

Bronze sculpture is unlike other art forms in that the artist must rely on the skill of others to achieve the final product. This is in contrast to painting, for example, where once the artist has signed the work, he has the final product. Even if the artist is casting the work himself, he almost always hires others to work with him. Therefore, the creation of a fine bronze is greatly dependent on the foundryman's skill and pride of workmanship.

For *Jumping Cholla*, I utilized the skills of Jerry Eaton of Sculptor Service in Sedona. At the foundry, Jerry and I spent a great deal of time discussing the best way to make the molds, and of course, he had to prepare cost estimates for the mold-making and casting fees.

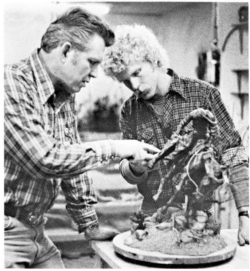

Left: Arriving at the foundry with the sculpture. Right: The author and Jerry Eaton, head of Sculptor Service, discussing how the molds will be made.

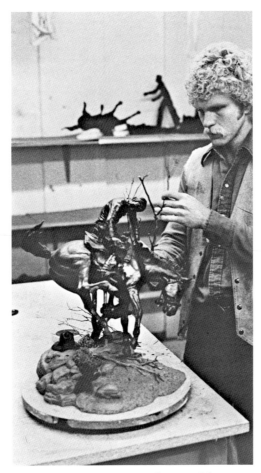

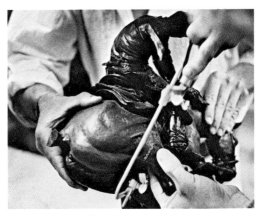

Using a jeweler's saw, Jerry Eaton is now
cutting off the right hind leg.

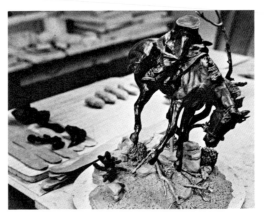

Jerry Eaton starts to disassemble
the sculpture.

The dissection of the sculpture
is almost complete.

At this time, the sculpture is photographed extensively. These photographs will be used to reproduce, as faithfully as possible, the waxes and the final bronze sculpture. From this point on, the sculpture is in the hands of the foundryman.

To begin the mold-making process, the sculpture must be disassembled, for it is necessary to reduce the sculpture to simpler forms. These simpler shapes are essential in making wax copies that can be removed from the mold with a minimum of distortion.

Items such as ropes and reins are removed first. Then, with the use of a jeweler's saw, the horse's tail and some legs are cut off, the man's arms and upper torso are removed, and the tree is cut into sections. This sculpture will require nine separate molds. The remainder of the horse is removed from the

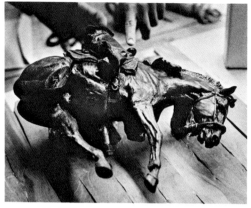

The horse is set in position to start the mold-making procedure.

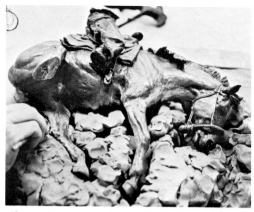

Clay is being placed around the horse to establish the approximate parting line for the mold.

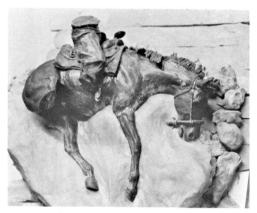

The parting line for the mold is progressing well.

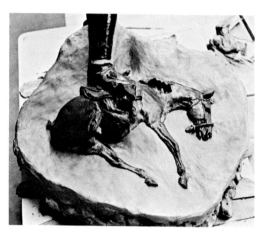

The parting line is now established.

base, and a process known as the "clay-up" begins.

The "clay-up" is the method by which the parting line of the mold is established. Clay is packed around the sculpture, and a parting line is very carefully laid in. Once this has been accomplished, the keys (depressions used to line up the two sides of the mold) and the outer lip are put in place. The sculpture is now ready to receive its first coat of rubber.

The rubber used to make the mold has a silicone base and comes in two parts mixed together by weight. Each side of the mold will receive five coats of this rubber. After the third coat, however, a layer of gauze will be added as a reinforcement. A fiberglass backing provides additional reinforcement after the fifth coat of rubber has set. This backing is necessary to hold the rubber mold in place. Without it, the rubber mold would not hold its shape.

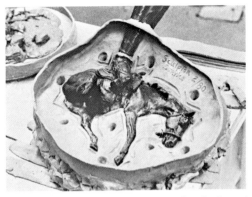

The keys and the outer lip are finished, and the sculpture is now ready to receive the first layer of rubber.

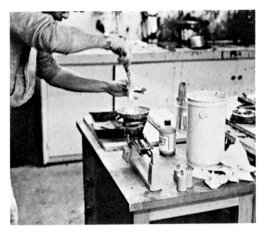

Mixing the rubber

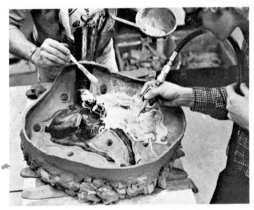

The first of five layers of rubber is being applied.

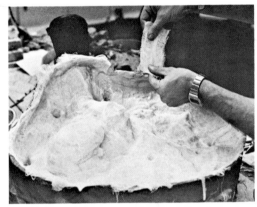

After the third layer of rubber, a gauze reinforcement is applied.

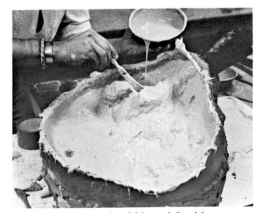

Here we see the fifth and final layer of rubber being applied.

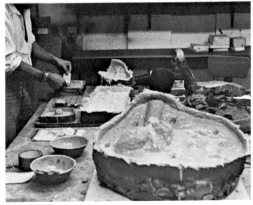

This photo shows the progress of all nine molds involved in the sculpture.

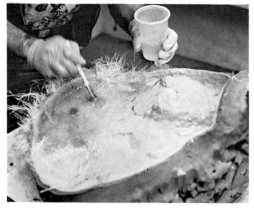

Fiberglass backing is applied to the
first side of the mold.

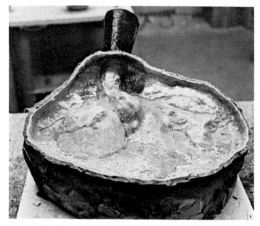

The first side of the mold is complete.

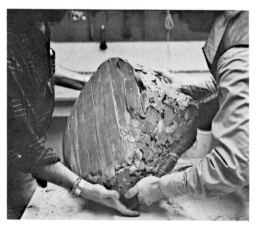

Mold being turned over

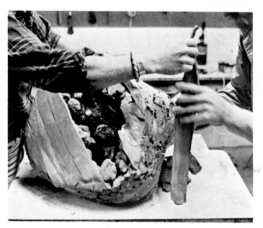

The clay is removed.

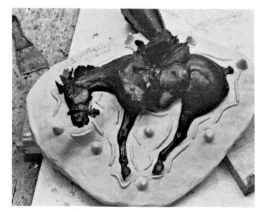

Second side of the horse mold being
made ready for first coat of rubber

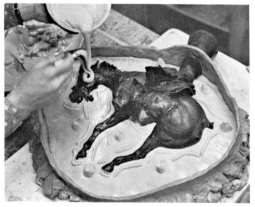

Starting the first coat of rubber
on the second side

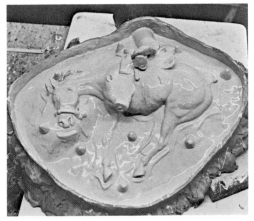

The first coat of rubber is complete.

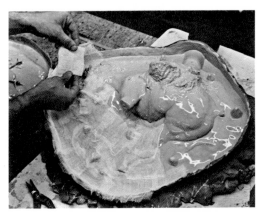

Gauze reinforcement being applied after third coat of rubber

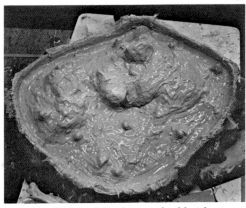

The fifth and final coat of rubber has now been applied.

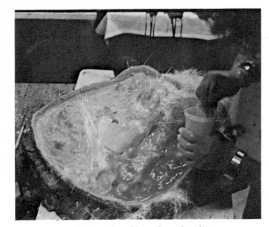

Applying the fiberglass backing

Now that the first side of the mold is complete, the mold is turned over, the clay is removed, and the whole process is repeated on the second side. Once the mold is complete, we are ready to start making wax copies of the original sculpture.

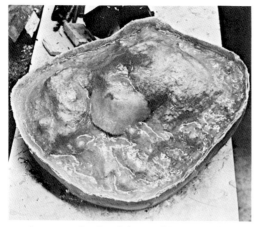

The second side of the mold is complete.

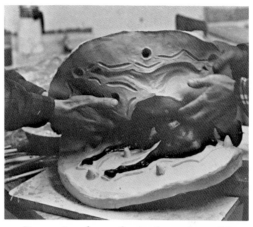

Removing the sculpture from the mold

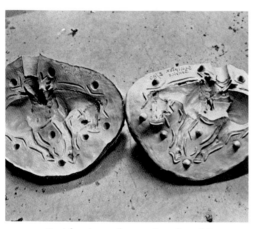

Inside view of completed mold

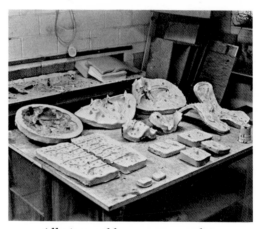

All nine molds are now complete.

The Wax

The molds are now complete. The next step is to make a hollow wax copy of the original sculpture. This is an important stage in the development of a bronze sculpture; from this stage on, each bronze in the edition must start from this point.

To get this hollow wax copy, the two sides of the mold are laid open, and molten wax is brushed on them. Each side of the mold must have a consistent wax thickness of approximately one-eighth inch. Then, as the photographs show, the edges and the wax splatter are cleaned up, the two sides of the mold are put together and tied in place, and molten wax is poured into the mold. The rubber mold is always shaken to ensure that both sides of the wax impression are welded together. The excess wax is then poured out of the mold, which is set aside to let the wax cool to room temperature.

This procedure is followed for all large portions of the sculpture. For the

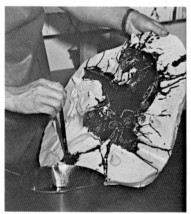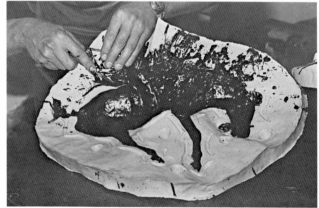

Left: Molten wax is brushed on each side of the mold to a thickness of one-eighth inch.
Right: The edges and the splatter are cleaned up.

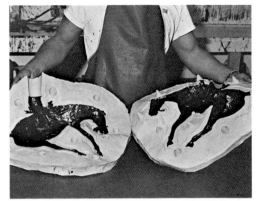

With the wax painted on them, both sides of the mold are ready to be put together.

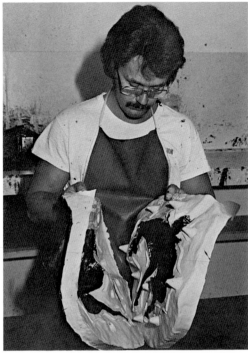

Putting the mold together

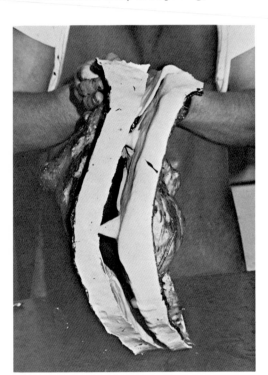

Both sides of the mold are in place.

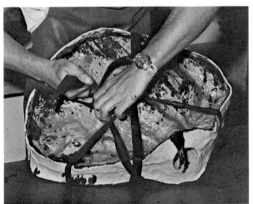

Here the mold is being tied together with rubber strips.

smaller or thinner parts, wax is injected into the mold and allowed to cool.

Once the waxes have cooled, they are removed from the molds and made ready for the "touch-up" process. This process is one in which highly skilled people take the waxes as they come from the mold and restore them, as nearly as possible, to the shape of the original sculpture.

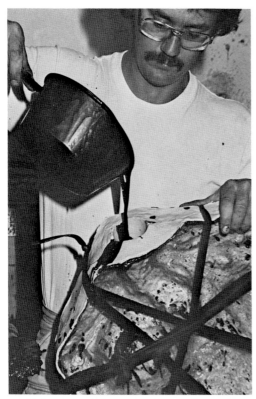

Molten wax being poured into the mold

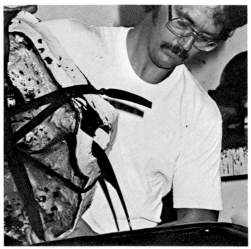

After the molten wax has been shaken in the mold, the excess wax is poured out.

The hollow wax impression is being removed from the mold.

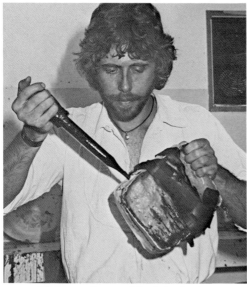

Filling another mold while the first one is allowed to cool

One side of the mold is removed.

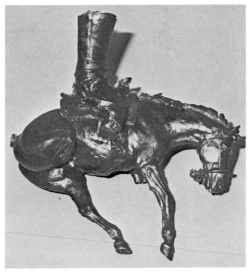

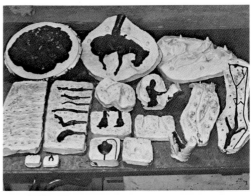

This photo shows all nine molds with a corresponding wax impression.

The wax impression as it comes from the mold

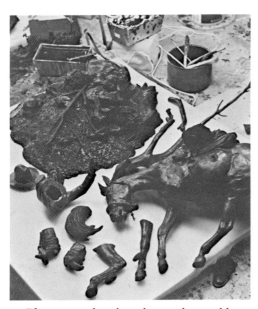

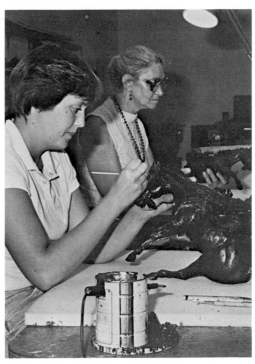

The waxes placed on the touch-up table

Highly skilled people at work on the touch-up or restoration process

Working from photos taken of the original sculpture, these people first remove all vestiges of the parting line. They next weld the various parts of the sculpture back together with the use of a hot tool such as a soldering iron or hot knife. Finally, they restore the textures of the original. The waxes are now ready for inspection by the artist.

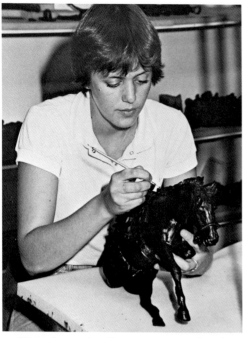

Here the parting lines are removed, and textures are being matched.

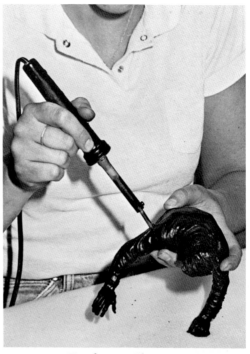

Touching up the man

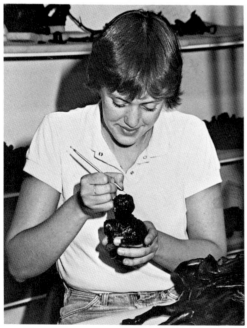

The man's arm is being welded on with the use of a hot tool.

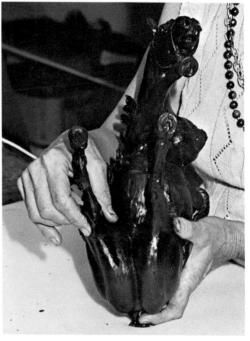

The horse's legs are being attached.

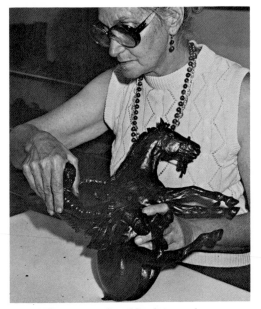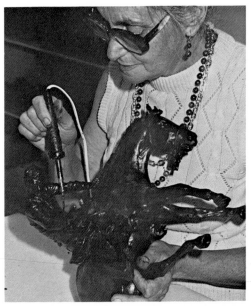

The man is fitted back into place.　　　The man is welded back onto the horse.

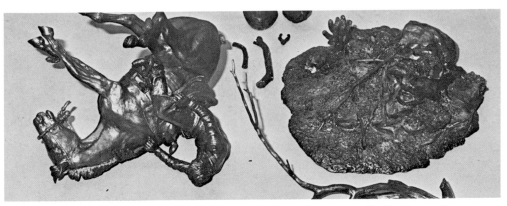

When all the parting lines have been touched up, the parts welded back together,
and the textures restored, the waxes are set aside to be inspected by the artist.

At this point, I go over each wax, correcting any imperfections I find. When I am satisfied, I sign my name in the wax base and inscribe the edition number. The waxes are now ready to be gated.

Gating is a process in which hollow wax rods are attached to the wax sculpture at various strategic points. These rods lead back to a wax funnel called the sprue. It is through this sprue that the wax eventually will be removed—to be replaced by molten metal. Once the gating has been completed, we are ready for investment and casting in bronze.

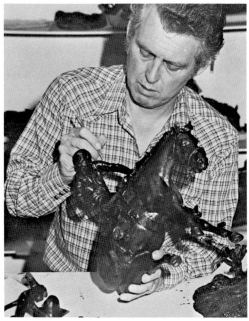

At this point, I go over each wax to ensure that it meets the requirements set forth in the original sculpture.

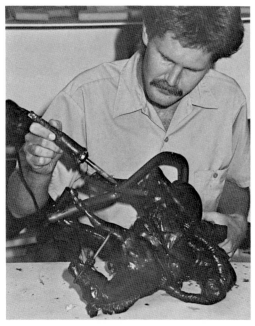

The wax is now being gated for casting in bronze.

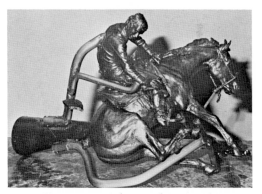

Here you see the gated wax ready to be cored and invested for casting.

When I am satisfied with the wax, I sign my name in the wax base and inscribe the edition number.

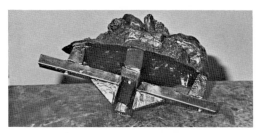

The base is gated for casting.

The Casting

The waxes are now gated (Figure 1), and we are ready to start the casting process. These waxes are approximately one-eighth to three-sixteenths of an inch in thickness and have a hollow cavity. If the final bronze casting is to match the wax original exactly, the inside of this wax cavity must be filled carefully. This process is called coring (Figure 2).

The first step in the coring process is inserting several bronze pins through the wax. These pins extend a short distance through both sides of the wax model and are necessary to keep the core in place later on. We are now ready to pour the core material into the wax cavity. This is done through a hole previously cut in the wax model. The core material, without using a lot of technical terms, can be described as being made up of glass (or silica), glue, and water. For the core, we must add another substance to this material to make it set up or harden by chemical reaction. With the core in place, we are ready to start making the ceramic shell or investment around the outside of the wax model (Figure 3).

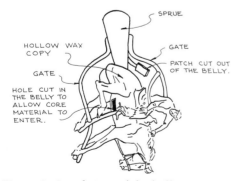

Figure 1: Gated view of the hollow wax copy

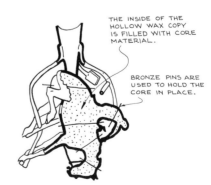

Figure 2: Cut-away view of the hollow wax copy with core pins and core material in place

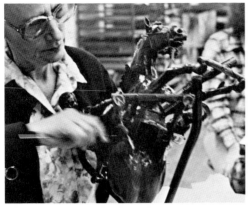

A bronze core pin is being pushed through the hollow wax model.

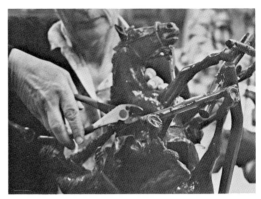

The pins extend approximately one-half inch on each side of the wax, and the excess is trimmed off.

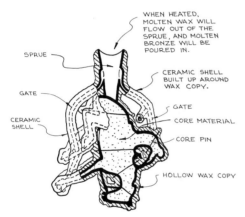

SPRUE

GATE

CERAMIC SHELL

WHEN HEATED, MOLTEN WAX WILL FLOW OUT OF THE SPRUE, AND MOLTEN BRONZE WILL BE POURED IN.

CERAMIC SHELL BUILT UP AROUND WAX COPY.

GATE

CORE MATERIAL

CORE PIN

HOLLOW WAX COPY

Figure 3: Cut-away view of the hollow wax copy with the ceramic shell around it

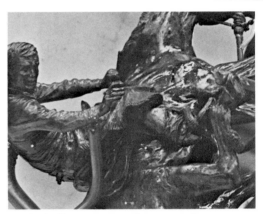

The hollow wax now has several core pins installed and is ready for coring.

As most people know, wax repels liquid. Therefore, the wax model must first be dipped in a cleaning solution and then into a solution that will break down this surface tension and allow the slurry (a mixture of glass, glue, and water) to adhere to the wax. The wax model is then dipped into the slurry, the excess is drained off, and while still wet, it is covered with a stucco coat. Stucco is really the same material as the slurry—but without the liquid. The first coat of slurry and stucco has a very fine consistency, and once this first coat is thoroughly dry, the process is repeated. In this manner, the surface texture of the wax model is accurately transferred to the inside of the ceramic shell.

After the wax model has received two coats of fine slurry and stucco, the same process will be repeated two more times—using a medium slurry and

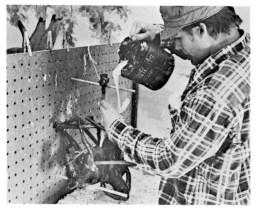

The core material is poured into the hollow cavity inside the wax model.

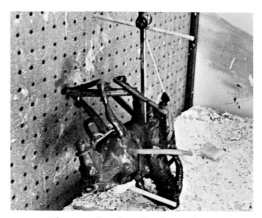

The core hardens in about thirty to forty-five minutes.

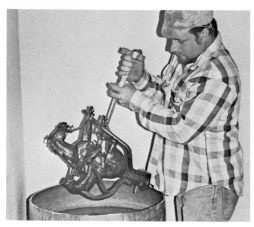

The wax is dipped into a cleaning solution.

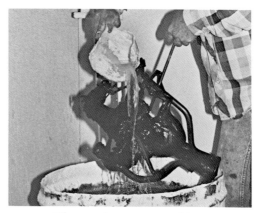

The wax is now covered by a wetting solution.

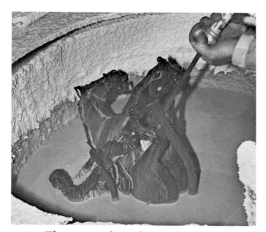

The wax is dipped into the slurry.

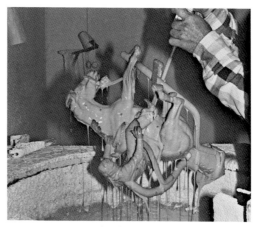

Draining the first coat of slurry

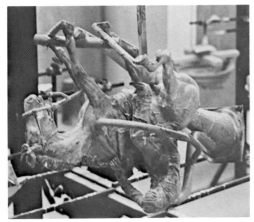

The first coat of slurry is allowed to dry.

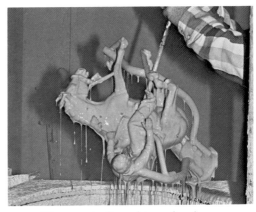

The wax is dipped into the slurry
for the second coat.

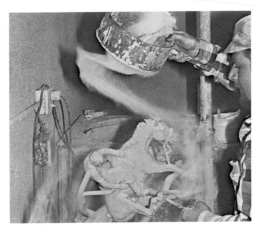

While still wet, the stucco coat is added.

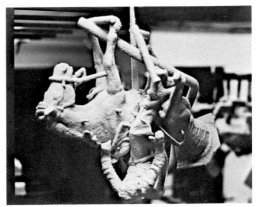

The second coat of ceramic slurry and stucco
is allowed to dry.

stucco and allowing the shell to dry thoroughly between each coat. The process is then repeated three or more times using a coarse material. Once dry, the shell receives a final or sealer coat of slurry. This last coat is free of loose stucco that could enter the mold after the dewaxing process. The ceramic shell is now complete, and we are ready to proceed with removing the wax from the shell and refilling the resultant cavity with bronze.

To remove the wax from the ceramic shell, the shell is placed upside-down in a burn-out oven that has been preheated to 1500 degrees. These high temperatures ensure that an outer film of wax will melt almost instantly and start to run out of the shell through the gates and pouring cup. This flash dewaxing is necessary to keep the wax from expanding and breaking the shell.

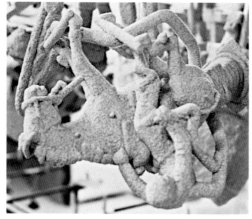

Fourth coat

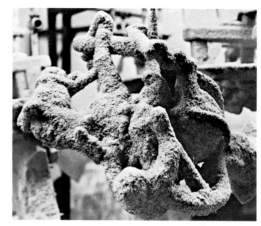

Seventh coat

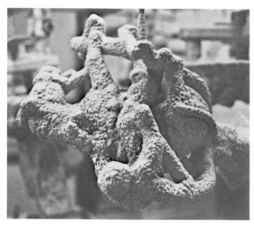

Final (or sealer) coat

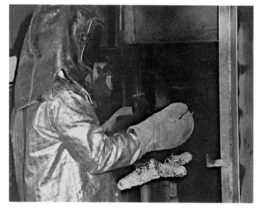

The ceramic shell is placed in an oven
that has been preheated to 1500 degrees.

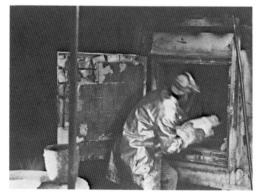

Approximately twenty hours later,
the shell is removed from the oven
and placed in a bed of sand.

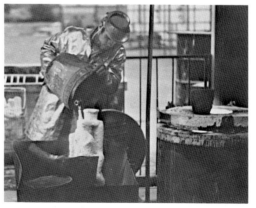

Extra sand is poured around the shell
to support it.

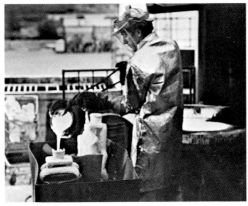

The molten bronze (heated to 2200 degrees) is poured into the ceramic shell.

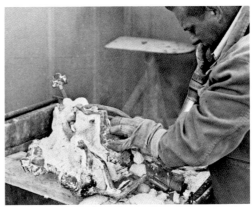

The ceramic shell is being removed from the bronze casting.

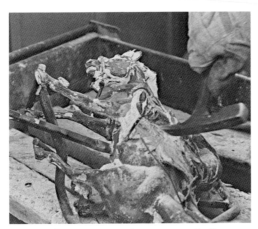

Chipping away the ceramic shell

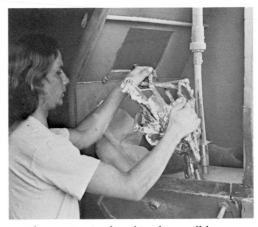

The casting is placed in the sandblaster.

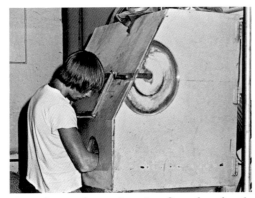

Here the workman is using fine glass beads to remove the remaining ceramic shell from the bronze casting.

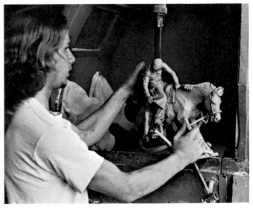

The clean bronze casting is removed from the sandblaster.

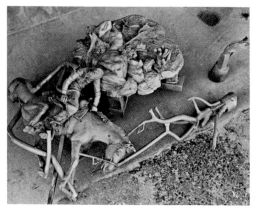

Here we see most of the parts after the shell
has been removed.

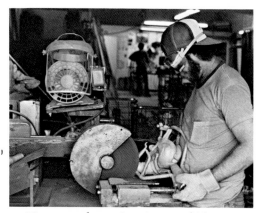

Here a workman is using a carbide saw
to cut away the gates from the bronze figure.

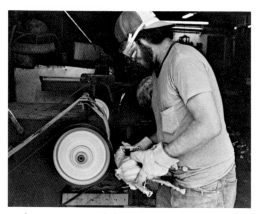

The remnants of the gate are ground away
with a sanding belt.

The sprues and gates are now cut away,
and the parts are ready for final assembly.

Once all the wax has run out of the shell, the shell remains in the burn-out
oven overnight to burn off any carbon or residues left inside. In the morning,
the foundry will melt the bronze that will be used for filling these shells.

The shells are removed from the oven, turned right-side up, and packed
in sand. The molten bronze, which has been heated to approximately 2200
degrees, is then poured into the shell—filling the cavity once occupied by wax.

After the bronze cools, the shell is chipped away, and the bronze is sand-
blasted to clean up all the recesses. The gates, which are now also bronze, are
cut off, and the bronze is handed over to the chaser for final assembly.

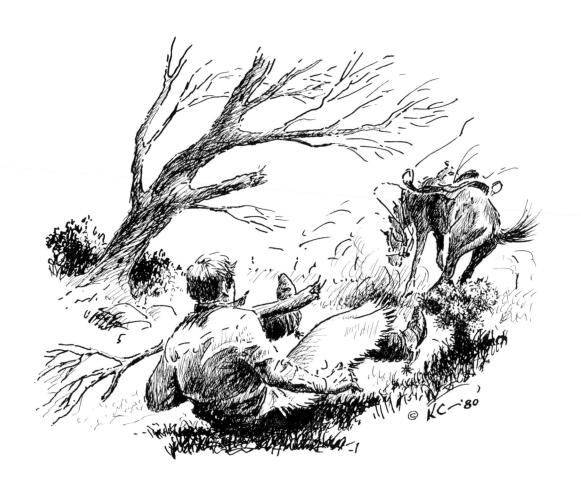

The Chasing

Chasing is the term used to describe the final assembly and finishing of a bronze sculpture. This is one of the most important steps in the creation of a bronze sculpture, for whatever the chaser does will show in the finished bronze.

The chaser, who is very often an artist in his own right, takes all the bronze parts and starts the process of producing a finished bronze. His first step is to match the parts and to identify and mark any imperfections in the casting.

He then welds the parts together, and with the use of small grinding tools, files, and chisels, he removes the imperfections and makes the welds disappear by matching the textures of the original sculpture. This is slow, meticulous work that usually takes several days to complete.

Many of the parts, such as ropes, reins, and saddle strings, are fabricated out of copper wire and silver soldered into place.

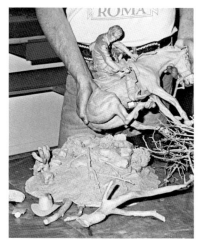 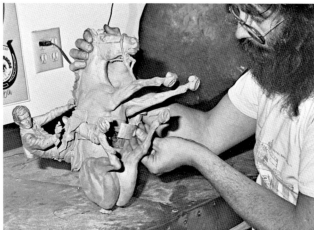

Left: The chaser picks up all the parts for the finished bronze sculpture.
Right: Fitting the parts together

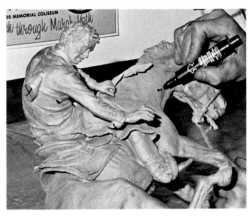

Here the chaser is marking all the areas that need to be welded or worked on.

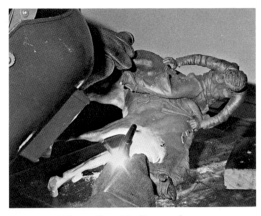

The tail and belly patch are welded together.

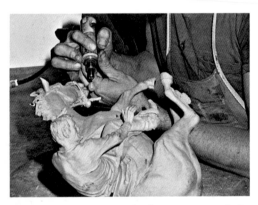

Being careful to match the textures of the original sculpture, the chaser will go over the welds with a small grinder.

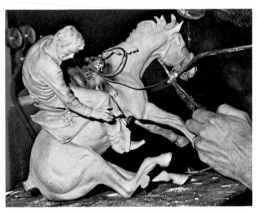

The reins, which are fabricated with copper wire, are silver-soldered into place.

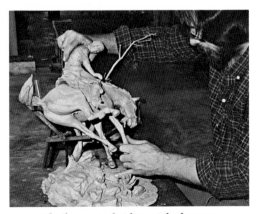

The horse and rider, with the tree, are fitted to the base.

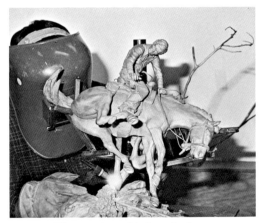

The tree is welded to the base.

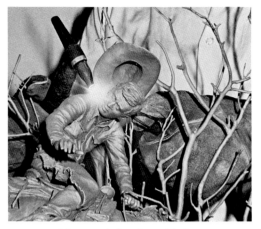

The man's hat is welded on.

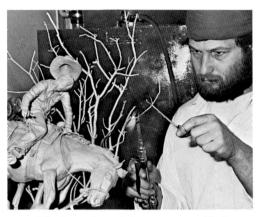

The branches of the tree are welded and silver-soldered on.

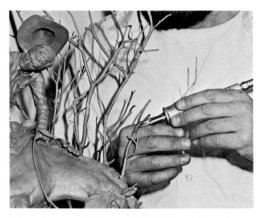

The chaser will go over all the soldered tree limbs to match the texture of the soldered areas with that of the sculpture.

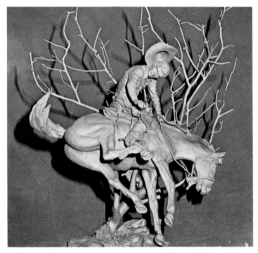

When the chaser is through, he will give the piece a final sand blasting, and the sculpture is ready to receive a patina.

Just as the people who touched up the waxes made extensive use of photographs depicting the original sculpture, the chaser uses these same photographs to make the finished bronze resemble the original sculpture as closely as possible.

Once the chaser has finished his work, he gives the bronze a final sandblasting. The bronze is then ready to receive a patina.

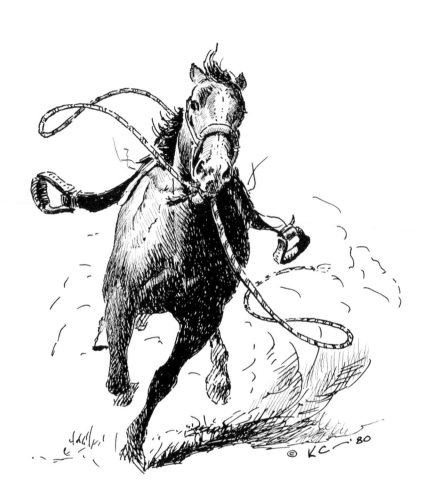

The Patina

The bronze is complete now, and all that remains is the application of a patina. Patina is the color applied to the surface of the bronze.

The bronze is first burnished by going over the piece with carbide paper. This burnishing (or smoothing) of the high points of the bronze helps give a variation to the final color.

A soft flame is then used to drive off the moisture in the bronze. It also warms the surface of the bronze and helps the surface accept the application of

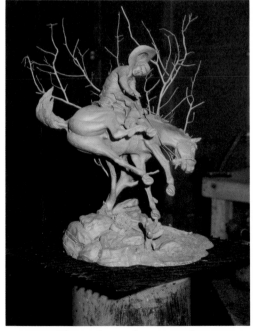

The sculpture is now ready
to receive a patina.

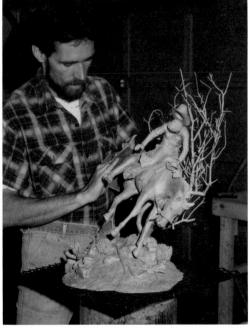

The sculpture is first burnished
with carbide paper.

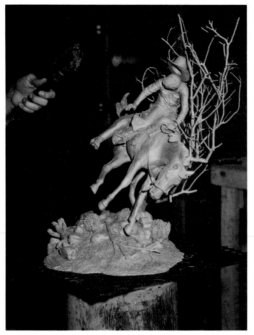

A soft flame is used to heat the bronze
and remove any moisture.

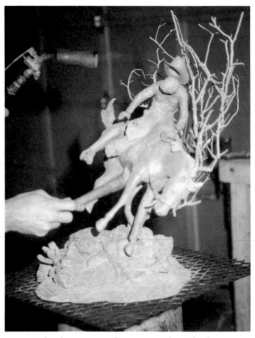

The bronze is first coated with the
acid cupric nitrate.

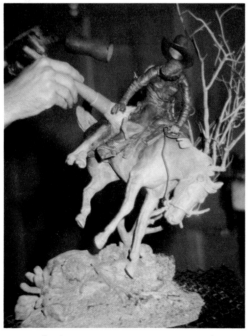

The bronze now receives a coat of
ferric nitrate.

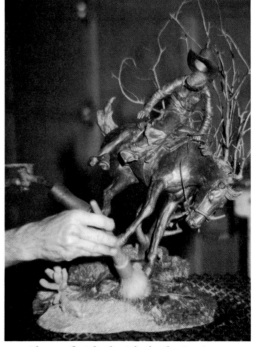

Almost finished with the ferric nitrate

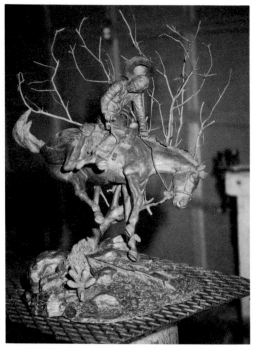

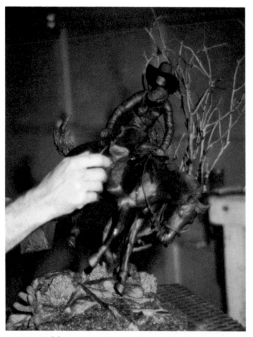

The bronze is allowed to cool.

Liquid beeswax is used to seal the pores
and stabilize the patina.

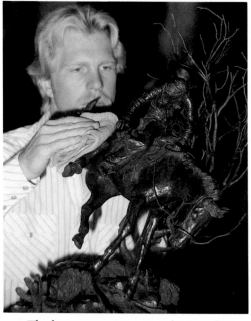

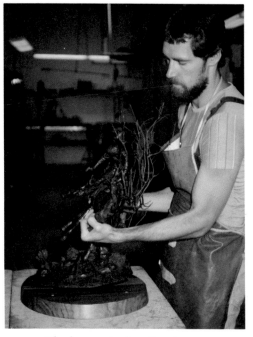

The bronze receives several coats of
paste wax and is hand rubbed
to bring out a luster.

The bronze is then fitted to a
black walnut base.

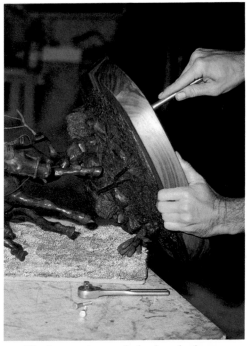

The bronze is now bolted to the base.

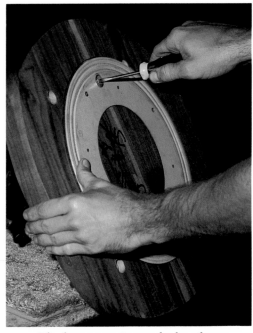

The lazy susan is attached to the underside of the base.

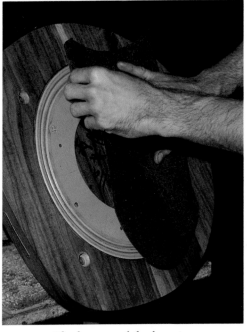

The bottom of the base is covered with felt.

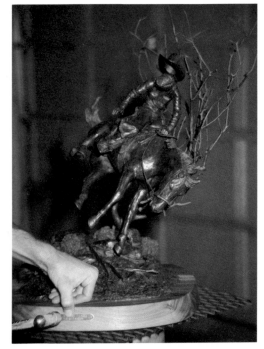

The name plate is nailed to the base.

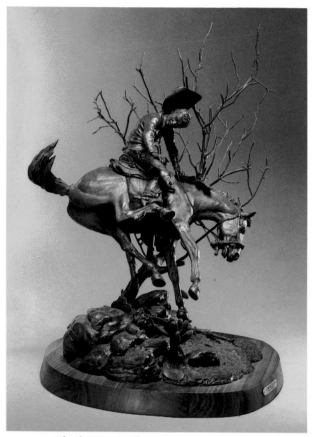
The bronze sculpture is now complete.

cupric nitrate. The cupric nitrate, an acid that is brushed onto the warm surface, turns the bronze green. Once the surface has a good coat of cupric nitrate, it is ready to receive the reddish color more commonly associated with bronze.

The reddish color is achieved by brushing ferric nitrate onto the warm surface. Once the desired color has been achieved, the bronze is allowed to cool.

When the bronze has cooled, a solution of liquid beeswax is used to seal the pores of the metal and stabilize the acids used to achieve the patina. Rubbing the bronze at this stage will bring up the first shine or luster.

Because the shine achieved from the beeswax does not last very long, the bronze receives several coats of paste wax. When this wax has been hand rubbed to a high luster, the bronze is ready to be bolted onto its wooden base.

Once the bronze has been mounted on the black walnut base, the name tag has been nailed in place, and the scuplture has been given a final buffing, *Jumping Cholla* is complete.

CHAPTER EIGHT

Summary

In the beginning of this book, I stated several questions that I hear most often. The first question was, "How long does it take to make the sculpture?"

To answer this question, I kept a log of the time spent on each phase of the process. This log reads as follows:

Sculpting the horse	12 days
Sculpting the saddle	3 days
Sculpting the man	8 days
Sculpting the base	3 days
Making the molds	12 days
Wax models	4 days
Casting	10 days
Chasing	3 days
Patina	1 day
Selling the bronze	?

It should be noted that I have counted only the days actually spent on the sculpture itself. I did not count the time spent on photography, nor am I counting weekends. It is also important to note that only rarely is a sculpture carried all the way from start to finish without interruption.

In estimating the length of time to make a bronze sculpture, I usually say four or five months from start to finish.

The second question I'm asked most often is, "How do you make it?" This is the question that, at least for me, has been the toughest to answer. If I answer simply that I sculpt it in wax and then have it cast in bronze, I immediately get a whole series of questions regarding the process. Those of you who read this book now understand why this is a tough question to answer, for it is a process that has to be seen rather than described.

It is my hope that the reader of this book will, at the very least, be left with the understanding that bronze sculpture is not a mechanical process and that each and every phase of its construction needs a skilled hand.

The third question was, "Why does it cost so much?"

I think, by now, the reader has some idea of the number of skilled man hours, not to mention the cost of buildings and expensive equipment, needed to produce a bronze. Whether it has artistic merit or not, a bronze will be expensive to produce.

In addition to the questions outlined above, I feel collectors and potential collectors should be aware of a few other items. The first is the artist's signature on the bronze.

This signature may or may not be an original signature. If the artist signed his original sculpture, his signature is in the mold. Many years ago, I followed this practice. At the present time, however, I sign each wax prior to casting. I believe my present practice gives the artist a greater degree of control over his molds and assures the collector of a better bronze. I also assign the edition number to each wax prior to casting. For example, if the wax is going to be number fifteen in an edition of thirty, I will mark it "15/30."

The
Experts Speak

© KC '80

Introduction

There are many men and women in this country who have acquired the reputation of being experts in the field of bronze sculpture because of their many years of hard work and the positions they hold. I have often wondered what their advice to collectors or potential collectors would be. With that thought in mind, I have approached several knowledgeable collectors and asked them what they would say if a friend asked them for advice on this subject.

Harold G. Davidson, a noted West Coast collector and dealer in fine arts, was born and raised in Winnipeg, Canada, where he was associated with the Richardson Brothers Art Gallery for eleven years. He later moved to Santa Barbara, taught at Santa Barbara City College, and began collecting and dealing in western art. In 1974, his book, *Edward Borein, Cowboy Artist*, was awarded the Western Heritage Award for the best art book of the year. He also is co-author of *The Etchings of Edward Borein*, which was published by John Howell in 1971, and has just completed a full-length biography of Jimmy Swinnerton.

Mr. Davidson, who describes himself as an "unreconstructed academician," lectures extensively on western art and has served as judge at art shows throughout the West.

Harold G. Davidson

The prospective buyer of a bronze is confronted with a bewildering array of merchandise, for the past ten years have seen a proliferation of bronzes displayed at art shows and auctions. Many well-established artists and newcomers have turned to the creation of bronzes in addition to their regular output of oils and watercolors. This is an excellent situation for competent artists who strive to become proficient in several mediums—not only to stimulate sales but also to expand creative horizons.

The criteria to use when contemplating the purchase of a bronze are similar to those you would apply when shopping for a painting. You look at subject matter and color, then size and price, and at this stage of your inspection you might find one or two bronzes that have a special appeal.

A person can learn to sharpen his or her powers of perception. Spend several months visiting galleries and museums, and you will begin to develop your own method of discernment. After you have scanned several thousand paintings, you should be reasonably good at spotting a superior work. Now you are ready for the next step, and if you expend the same time and energy looking over the "bronze scene," you can sharpen your eye rather quickly and begin to realize what to look for in any piece of art. You will find that you are mentally rejecting many pieces, but certain bronzes are beginning to appear desirable. Once you have developed this visual sense of judgment, you are ready to buy. If you are an impulse buyer and, of course, have an innate sense of good judgment, you just might succeed in finding a good piece at a fair price.

The first step is to look around and see which bronzes catch your attention and leave you with a good impression. Then examine your favorites closely and look for certain details—such as modeling. Do the proportions seem correct, and does the horse, for example, look like the horses you have seen? Does the bronze have a pleasing patina, or does it look artificial or contrived? Some

bronzes may have a polychrome finish, with paint over part or all of the surface. I have asked many collectors for their opinions concerning color on bronzes, and the majority are opposed to the idea, taking the stand that a bronze is a bronze, etc. Many sculptors solve the problem by producing two editions, one with a polychrome finish and the other with the regular dark brown patina. However, sculptors have been painting their work since the dawn of time, so this becomes a personal decision, and it is up to you, the buyer. Don't let color bother you if you like the piece.

A good bronze, regardless of the subject matter, will fit into almost any type of art collection, be it western or any other style. It might even create more interest and attention than many of your paintings, for it usually has its own little space, such as a tabletop or pedestal, whereas paintings are sometimes lost when hung among other paintings.

The size of the bronze is an important consideration. Do you have a place for it in your home or office? Fortunately, most modern homes are spacious, and a well-placed sculpture will enhance any room or hall. Smaller pieces can be placed almost anywhere, and I have seen collections of small bronzes handsomely displayed in glass cabinets. Naturally, the mantel over your fireplace makes a perfect setting to show off your bronze treasures. Consider also the weight factor, for a heavy piece needs a sturdy, well-braced surface to avoid a catastrophic fall. Do not try to move a heavy work yourself: always get muscular assistance.

A buyer should be able to find a suitable bronze at a reasonable price. Many superb castings are available in the three hundred to five thousand dollar price range. The larger, more expensive bronzes usually are done by noted, established artists, but in any price bracket, there is an amazing number of good buys.

The process of modeling a figure in wax or clay and then having it cast at a foundry is a time-consuming and costly operation. I am sometimes amazed at how reasonably priced some bronzes are when this lengthy process is taken into consideration. On a one-to-one basis, there is an impression that bronzes are more expensive than paintings, but I have not found this to be true. Sculptors who have a following of steady collectors sometimes "sell from the wax," i.e., they accept orders for finished bronzes from the original wax model. Others use a progressive pricing based on edition numbers; the majority of contemporary artists, however, maintain one price for an entire edition of a bronze.

Bronzes are usually cast in editions, ranging in number from one to a hundred or more—with an edition of twenty being a common figure. The number is usually incised into some lower area of the bronze, e.g., 2/20, 7/20, etc. Additional information might include the piece's title, the artist's name, the copyright symbol, and sometimes the name of the foundry. There are col-

lectors who want only a certain number, such as number five of every edition produced by the artist. Actually, because of the artist's final touchup, every bronze in the edition is just a little different from every other one. This should explode the myth that the lower the number, the better the bronze. There was a time when this was true, but today, with new molding material available, number twenty can be just as good, or possibly better, than numbers one and two. Occasionally, an artist will produce a second edition of twenty, and it is usually noted on the bronze.

Many artists issue a certificate with each bronze, stating the total number cast, the number of the one you have just purchased, and also declaring that after the last bronze of the edition is finished, the mold will be destroyed. Other details such as title, dimensions, date of casting, and the name of the foundry are usually on the certificate of authentication. Not every sculptor issues these certificates, so do not be disappointed if your bronze does not have one.

It is time now to examine critically your proposed bronze, and there are many factors to consider. An artist has to think differently when sculpting. A painted landscape has a two-dimensional surface and atmosphere, such as sky and clouds. A bronze is three-dimensional and has no atmosphere. The immutable laws of composition and perspective apply equally to bronze and painting. Is your selection pleasing to your eye, and would you be happy to give it a place in your home? Are the proportions correct, or do you think the horse's head is too large, the hoofs too small, or perhaps the animal looks static instead of appearing animated. The artist should have researched his subject so that the details in his work, while not necessarily authentic, at least look like the real thing. A good bronze should tell a story.

There is a tendency sometimes to have an excess of details, such as barbed wire, cactus, trees, stones, etc., which tend to detract from clean lines. A three-dimensional effect is difficult to achieve in paintings, but it should be evident in sculpture. A buffalo painted on canvas can be flat, but when executed in bronze, it should have a well-rounded rump, thick hairy legs, and a massive neck and shoulders. An exception to this would be an artist's deliberate attempt to caricature a subject.

Now you have your primer and are ready for the search. It will be a gratifying experience for you. Good luck and happy hunting!

Jim Clark is no stranger to the world of fine western art. For more than twenty years, as art dealer, gallery owner, and major collector, his expertise has gained him an international reputation as one of the foremost authorities on the subject— as sophisticated in his knowledge of the old masters as he is with the works of their contemporary peers. A pioneer collector in his own right, Clark's clients now number among the premiere collectors in the nation, and his first-hand association with today's best western painters and sculptors has resulted in his organizing two of the country's most prestigious annual western art shows—the Biltmore Celebrity Show in Los Angeles and the Haley Library Art Show in Midland, Texas. Born in Amarillo, Texas, Clark currently resides in Scottsdale, Arizona.

Jim Clark

Today's collector has some really fine pieces of bronze sculpture from which to choose. Many distinguished contemporary artists choose to work in bronze because it is a beautiful media for both expression and impression. Unfortunately, literally tons of bronze being poured and formed today are destined to become doorstops and anchors because any resemblance between these sculptures and art is pure accident. The real shame of it is that many such "works of art" wind up in the hands of beginning collectors, who quickly become disappointed and disillusioned with these pieces as they become more knowledgeable. For that reason, I believe that beginning collectors would do well to find an art dealer experienced in bronze sculpture who is sympathetic to their needs and heed his or her advice.

A desirable bronze sculpture always includes and is dependent on the following traits: it is cast in a relatively small edition; the subject and the way it is handled show originality; there is a special character, life, and expression to the piece; and finally, individual artisans at the foundry work closely with the artist to produce a clean, well-finished bronze.

Rarity is a very important consideration in selecting a bronze sculpture. Although few bronzes are cast as one-of-a-kind pieces, those cast in small editions are very sought after, and many become extremely valuable works of art. A few years ago, most editions of bronzes were kept short by necessity. Mold materials simply would not hold up for more than a few castings. The greater value of these art works today has been determined to a large extent by their short supply. For that reason, some of today's artists are doing themselves and their collectors a real disservice by producing large editions and, even worse, multiple editions with a substantial number of castings in each edition.

A bronze totally original in theme and execution is almost impossible to find today. An accomplished artist, however, can take a seemingly timeworn

subject and give it a life and character so different from all apparently similar pieces that most people will not even recognize the relationship between them.

One of the first lessons a new collector must learn is that not everyone who can carve or form a recognizable figure is an artist. Only the few sculptors who have the understanding, the talent, and the ability to put character and expression in a cold piece of metal are truly artists. These people can and do create lasting works of art that will stand the test of time. A really fine bronze sculpture will not be stiff or frozen but should flow with life and warmth. A portrait, for example, must be more than a mere likeness; it must capture those things that make a subject worthy of being immortalized in bronze. A piece depicting an event should tell a story—a very short story—and must stay as uncomplicated and original as possible. When a bronze tries to tell too long a story, its effect is muddled. All too often, such bronzes seem merely to be large groups of figures—each unrelated to the other.

A close relationship between the artist and the foundry is absolutely necessary in creating a superior bronze sculpture. A bronze produced by a good foundry under the close supervision of the artist will be crisp and clean with a patina that is free of splotches, discolorations, and minor flaws.

If new collectors will keep a few key words in mind in selecting bronzes—words such as imagination, life, expression, design, mood, character, and originality—they stand a good chance of being happy with the selections that they make. Above all, I would like to tell these new collectors not to be discouraged; a fine bronze sculpture is worth the time and research required to find it. They will enjoy it forever.

Glossary

Armature: A framework or brace an artist uses to support the clay or wax when doing a sculpture

Calipers: A wooden, scissorlike tool used for measuring or checking the proportional distances of a sculpture

Casting: 1. Pouring molten metal into a prepared mold (the ceramic shell) to obtain a particular shape. 2. The metal sculpture after it is removed from the mold (ceramic shell) but before it has been finished.

Ceramic Shell: Silica material that is built up around the hollow-wax model to form the heat-resistant mold. Note: the ceramic shell is a modern industrial process that has many advantages over the more ancient methods for the casting of bronzes. The chief advantages of the shell process are that the shell is thinner, and it requires less burn-out time (and fewer gates). Surfaces are also improved because gases can escape through the wall of the shell. These shells have the added advantage of being easier to handle because they are lighter than those used in the older method.

Chasing: The work done on the surface of the casting to restore the sculpture to its original shape and texture. The individuals who do this work are referred to as "chasers."

Clay-up: The building up of clay around an original sculpture to establish a parting line for the rubber mold

Core: The heat-resistant, plasterlike material used to fill the inside of a hollow-wax model to produce a hollow-bronze casting

Coring: The act of pouring core material into a hollow-wax model that has been

prepared with core pins. Within a few minutes of pouring, the core will be solid, and the wax model is then ready for investing in a ceramic shell.

Core Pins: Copper rods inserted through hollow-wax models to hold the core in place after the wax has been melted out of the ceramic shell

Cupric Nitrate: A chemical used to impart a greenish color to the bronze sculpture

Dewaxing: A process in which the shell containing the hollow-wax impression and core are placed into an oven where the wax is burned out. The term "lost wax" comes from this step in the casting process.

Ferric Nitrate: A chemical used to impart a reddish color to a bronze casting

Foundry: A place of business where metal is melted and poured into a mold to produce a cast metal shape. Art foundries perform a variety of functions including: mold making, preparing hollow-wax models, pouring the bronze, and finishing the castings.

Gating: A process in which wax rods are attached to the hollow-wax model, forming a channel whereby the wax can flow out of a shell, and the bronze can flow into it

Hollow-Wax Model: The wax impression of a sculpture made from the rubber molds. Hence, the terms "hollow-wax model" and "hollow-wax impression" can be used interchangeably.

Investing: Term used to describe the steps involved in building up the ceramic shell around the hollow-wax model

Investment: The material used to make up the ceramic shell

Jeweler's Saw: A saw with a very fine blade used to cut apart wax or clay models. When used, it leaves little evidence of the saw marks.

Original Model: An artist's original sculpture, usually made out of wax or clay. It is usually mutilated in the mold-making process and is considered to have served its purpose once the molds are made from it.

Patina: The color added to a bronze sculpture by the use of heat and chemicals

Shell: See ceramic shell

Slurry: The liquid form of the investment material used to make the ceramic shell

Stucco: A material similar to slurry (see preceding page) but prepared without liquid. It is used in making the ceramic shell.

Sprue: A wax funnel that all the gates attach to. During the dewaxing, all the wax runs out through the sprue—leaving an opening for the molten bronze to enter the shell.

Touch-up: The work done on the surface of the hollow-wax model after it has been removed from the rubber molds. This work includes removing the parting line, repairing defects, and reattaching the various parts.

Wax Sculpture: This is the original sculpture done in wax by the artist, but it can also refer to the hollow-wax models or impressions that are pulled from the molds.

DESIGNED BY MICHAEL HOLLAR
COMPOSED IN PHOTOTYPE TRUMP
WITH DISPLAY LINES IN FRIZ QUADRATA
PRINTED ON MOUNTIE MATTE
AT THE PRESS IN THE PINES

NORTHLAND PRESS

BOUND BY ROSWELL BOOKBINDING